CLASSIC
ROCK

Photographs from Yesterday & Today

photos by **Jim Summaria** ■ words by **Mark Plotnick**

AMHERST MEDIA, INC. ■ BUFFALO, NY

Back cover photos:
top—Johnny Winter, 1975
center—Kim Simmonds, 2015
bottom—Ronnie Montrose, 2011

Published by:
Amherst Media, Inc.
PO BOX 538
Buffalo, NY 14213
www.AmherstMedia.com

Publisher: Craig Alesse
Associate Publisher: Katie Kiss
Senior Editor/Production Manager: Michelle Perkins
Editors: Barbara A. Lynch-Johnt, Beth Alesse
Acquisitions Editor: Harvey Goldstein
Business Manager: Sarah Loder
Marketing Associate: Tonya Flickinger

ISBN-13: 978-1-68203-410-1
Library of Congress Control Number: 2018960609
Printed in the United States of America
10 9 8 7 6 5 4 3 2 1

AUTHOR A BOOK WITH AMHERST MEDIA

www.facebook.com/AmherstMediaInc
www.youtube.com/AmherstMedia
www.twitter.com/AmherstMedia
www.instagram.com/amherstmediaphotobooks

CONTENTS

YESTERDAY: ROCKERS OF THE '60s & '70s

TODAY: ROCKERS WHO ARE/WERE STILL ROCKIN' IN THEIR 60s & 70s

ABOUT MARK PLOTNICK

Mark Plotnick co-authored the consumer guide, *The $mart Money $hopper* (Perriday, 2nd ed., 1984). With his expertise, Mark and his co-author were the subject of many newspaper and magazine interviews. They also appeared on Chicago-area radio and television shows, including *The Oprah Winfrey Show.* This experience launched Mark into new, eclectic career directions, including marketing, copywriting, publicity, trade magazine journalism, and the writing of widely consulted marketing-research studies for a variety of U.S. and international companies. Now retired, he focuses on his life-long passion: writing about and playing music.

Mark earned a B.S. in Biology at Loyola (Chicago) University and attended one year of professional school at the Illinois College of Optometry.

Dedication—Mark dedicates this book to his late mom and dad, who gave him the gift of piano at age seven and once asked inquisitively why blues guitarists like B.B. King made those grimacing faces. And to his loving wife, Hope, who showed unending patience during this project and has come to enjoy the rock music knowledge packed inside Mark's head. Oh yes . . . and for letting him play his keyboards turned up to 11.

Acknowledgments—Thanks to my dear friend, Jim Summaria, for asking me to participate in this project, giving me something meaningful to do following retirement, and for the spirited discussions we have as rock 'n' roll comrades-in-arms. Thanks to Oprah Winfrey, who many years ago took a chance on two complete unknowns with a book to appear on her show. It changed my life professionally. Thanks to my dear departed friend, "Big Al" Day, a gifted piano and organ teacher who was my shopping buddy for all things keyboards. And to my beloved friend, Ed Siena: thanks for being my best audience and promoter since 1977! And finally, many thanks to my earliest musical heroes, Eric Clapton, Peter Green, Duane Allman, and Johnny Winter. Their records led me to Robert Johnson, Howlin' Wolf, Willie Dixon, Muddy Waters, the Kings, B.B., Albert and Freddie, Otis Spann, and all of the other bluesmen and blueswomen who contributed so much to America's rich musical heritage.

Photo Credits—Yesterday photo by Mark Plotnick (1974), today photo by Jim Summaria (2018).

ABOUT JIM SUMMARIA

Chicago native Jim Summaria is a veteran rock concert photographer whose photos have been published in numerous books, CDs, and publications such as *Premier Guitar* and *Good Times* (Germany). His lifelong passion for rock photography began as a 19-year-old armed with a Kodak Instamatic at a 1972 Rolling Stones concert (you can see his first photo on the following page). Thrilled with his first (albeit sometimes blurry) efforts, he soon invested in a 35mm camera with a zoom lens, sneaking onto the main floor of a Led Zeppelin concert and snapping professional quality photos. One of the photos was posted at a local record shop impressing the manager, who hired the 20-year-old to be the official photographer for a major Chicago concert promoter.

Thus began an odyssey of shooting every major rock act of the '70s from Elvis and Rod Stewart, to Paul McCartney and the Who, and many more. After a "side trip" into his main career in corporate photography, Summaria returned to the rock concert scene in 2008, shooting many of the same acts whose careers have endured, and creating the unique "then and now" portfolio few photographers have.

Dedication—This book is dedicated to my wife, Sheila, and my children, Melissa and Michael, for all their love and support, and also for letting me play my music at 11.

Acknowledgments—Thank you to my mom and dad for bringing the sounds of Frank Sinatra, Dean Martin, and the big bands into our house. Thank you to my brother, Joe, for introducing me to the rock and roll pioneers Elvis Presley, Chuck Berry, and Little Richard. Thank you to my sister, Cynthia, whom I shared Beatlemania with and for bringing me to my first concert (The Young Rascals, Mitch Ryder and The Turtles) in 1966.

A special thank you to Rich Carlson, Larry Rosenbaum, and Carl Rosenbaum of Flip Side Productions for the 1970s backstage passes and taking a chance on a 19-year-old photographer, and to Ron Onesti, the owner of the Arcada Theater in St. Charles, IL, for the photo passes to any 21st century show to help me capture classic rock artists still performing today.

Thank you to the following people who helped me in my photography career and otherwise: Marv Chait, John Medicino, Bill Decker, Terry House, Mark Clark, Ed Siena, Tom Caprile, Shawn O'Malley, Mike Calcina, Gerry Hurley, Robbie Glick, Fabian Leibfried, Rich Osweiler, Steve Duchrow, Steve Ozark, Kim Simmonds, Andy Powell, Mike Pinder, Paul Nelson, Ronnie and Leighsa Montrose, Mark Plotnick, Marc Fleming, Garry Kubowicz, Dave Slania, Frank White, Dan Muise, Mark Anderson, Lou Belotti, and Lisa Torem.

Finally, thanks to all of the softball players whom I have coached, plus the assistant coaches and teammates.

Photo Credits—Yesterday photo by Mark Clark (1974), today photo by Melissa Summaria (2018).

FOREWORD

This book is not a complete compilation of all classic rock acts or necessarily the most important ones. It aims to pay tribute to the acts that photographer Jim Summaria was fortunate enough to shoot in performance and backstage, both yesterday and today.

The spotlight is on the golden era of classic rock, when accountants had boundaries and engineers kept the tape machines rolling overtime (despite the costs), hoping to capture moments that made recorded rock and roll history.

For those artists still performing into their 60s and 70s, the physical changes revealed in Jim's pictures can be stark, but their on-stage passion remains as genuine and durable as ever. These acts still work tirelessly to provide a few hours of musical escape and nostalgia for their devoted fans, who spend hard-earned dollars to see them perform.

Enjoy the images and information within these pages—and keep on rocking.

The photo that started it all. Rolling Stones, International Amphitheater, Chicago, IL, 1972

YESTERDAY

'60s and '70s Rockers

LED ZEPPELIN

formed 1968; Jimmy Page (guitars, backing vocals, and producer), Robert Plant (lead vocals, harmonica), John Paul Jones (bass, keyboards, mandolin, backing vocals, and arranger), and John Bonham (drums, percussion, and backing vocals)

- One of the world's top-selling music acts, with an estimated 300 million-plus units sold. They were inducted into the Rock and Roll Hall of Fame in 1995.
- The origins of Led Zeppelin took root at a recording session for Jeff Beck's 1968 debut solo album, *Truth*. The chemistry between contributing musicians Jimmy Page and Jeff Beck (former Yardbirds), Keith Moon and John Entwistle (The Who), and John Paul Jones (popular session musician) led Page to consider forming a new band named The New Yardbirds.
- Page's idea for a new band was met with sardonic remarks from Keith Moon, who said his new band would "go over like a lead balloon." Entwistle followed with, "more like a lead zeppelin."
- When naming the band, Page changed "lead" to "Led" to avoid word confusion.
- Legal threats over the Led Zeppelin name were made by the family of Ferdinand von Zeppelin, the founder of the German airship company.
- Page's unorthodox use of a violin bow across his guitar strings was the idea of Scottish violinist and orchestra leader, David McCallum Sr.

previous page spread—Jimmy Page and Robert Plant, Chicago Stadium, Chicago, IL, 1977

top left—Jimmy Page and John Paul Jones, Chicago Stadium, Chicago, IL, 1977

bottom left—Robert Plant, Chicago Stadium, Chicago, IL, 1977

- The band originated the concept of Album Oriented Rock (AOR).
- "Stairway to Heaven," the rock song with the most AOR radio airplays ever, was never released as a single.
- After the LP *Physical Graffiti* topped the charts in 1975, the band's previous five albums returned to the Billboard charts—a first in rock music history.
- For their 2007 London reunion show, there were an estimated 20 million requests for 16,000 tickets.
- Dave Grohl (Nirvana, Foo Fighters) told *Rolling Stone* magazine, "Heavy metal would not exist without Led Zeppelin, and if it did, it would suck."[1]

top right—Jimmy Page, Chicago Stadium, Chicago, IL, 1977

below—John Bonham, Chicago Stadium, Chicago, IL, 1977

JEFF BECK

guitarist, songwriter, and composer

- Inducted twice (1992 and 2009) into the Rock and Roll Hall of Fame as a member of the Yardbirds and as a soloist.
- *The New York Times* called him "The greatest guitarist that millions of people have never heard of." [2]
- Albums *Blow-by-Blow* (1975) and *Wired* (1976) are two of the top-selling guitar instrumentals ever recorded.
- Won six Grammy Awards in the Best Rock Instrumental category.
- His passion for vintage cars and hot rods competes with his love of music.
- Beck told *USA Today*, "There were times when I treated my guitars as a nuisance. I looked at one the other day and thought, 'Thanks a lot pal, you got me all around the world.'"[3]
- In 1965, Jimmy Page was the Yardbirds' first choice to replace Eric Clapton, but he declined and recommended boyhood friend, Jeff Beck.
- The original Jeff Beck Group (1967–1969) was scheduled to appear at Woodstock, but Jeff disbanded the group prior to the festival.
- Beatles producer, George Martin, produced and arranged Jeff's 1975 all-instrumental landmark album, *Blow-by-Blow*.

top and bottom left—Arie Crown Theater, Chicago, IL, 1975

left and right—Kim Simmonds, Auditorium Theater, Chicago, IL, 1975

SAVOY BROWN

formed 1966; core lineup 1969–1971: Kim Simmonds (guitar), Chris Youlden (lead vocals), "Lonesome" Dave Peverett (guitar, vocals), Roger Earl (drums, percussion), Tony Stevens (bass), and Bob Hall (piano)

- Welsh-born Kim Simmonds founded the band at age 19. He remains the only constant over the band's six-decade history.
- At the age of 13, Simmonds taught himself guitar with the help of his brother's impressive record collection.
- The name "Savoy" was borrowed from the American blues record label, and "Brown" was chosen for its simple, bluesman-sounding phonetics.
- In 1971, three members left to form the boogie-band, Foghat.
- Reflecting on his long career, Simmonds said, "When I go onstage playing guitar, I want to prove that I'm still one of the best. I feel it's important for old dogs like myself to contribute and keep doing my bit to help blues-rock along its path."[4]

FOGHAT

formed 1971; classic lineup: "Lonesome" Dave Peverett (lead vocals, guitar), Rod Price (vocals, guitar, slide guitar), Tony Stevens (bass), and Roger Earl (drums)

- Peverett, Stevens, and Earl previously played in the British blues band, Savoy Brown, led by guitarist Kim Simmonds.
- The band's name was a nonsensical word Peverett invented while playing Scrabble with his brother.
- Foghat toured continuously from 1971 to 1983 and averaged eight months of the year on the road.
- Peverett's nickname, "Lonesome," referred to the many hours he spent at home listening to blues records.
- In later years, new audiences discovered Foghat's songs in movies, TV shows, ads, and video games.
- Drummer Roger Earl once auditioned for the Jimi Hendrix Experience. As of 2018, he remains the only original member in the current Foghat lineup.

top left—"Lonesome" Dave Peverett, Auditorium Theater, Chicago, IL, 1974

bottom left—Tony Stevens, Auditorium Theater, Chicago, IL, 1974

RICK DERRINGER

guitarist, singer, songwriter, and producer

- Enthused by the pistol logo of his first record label (Bang), Richard Zehringer adopted the stage name Derringer.
- He formed the McCoys at age 13. The band's 1965 number-one hit, "Hang on Sloopy," became the official rock song of Ohio, his home state.
- In 1970, the McCoys joined forces with blues guitarist Johnny Winter to form Johnny Winter And.
- BMI awarded Derringer's hit song "Rock and Roll Hoochie Koo" a Special Achievement Citation for reaching one million performances.
- Derringer played on and produced several Edgar Winter albums.
- Derringer told *Vintage Guitar* magazine, "I've found that my music, whether it's blues or rock or whatever you call it, can be channeled into a positive direction that actually helps people . . . I never knew music could have such power."[5]

above—Auditorium Theater, Chicago, IL, 1974

JOHNNY WINTER

guitarist, singer, songwriter, and producer

- One of the greatest rock-era practitioners of American rural and post-war urban blues.
- At age 17, he snuck into a black music club and persuaded B.B. King to let him perform using King's guitar.
- In 1969, he signed with Columbia records for a sum that was the label's largest signing contract at that time.
- Produced several Grammy-winning blues albums with Muddy Waters.
- After several lost years due to health issues, poor management, and substance abuse, musician-producer Paul Nelson revitalized Johnny's career out of deep respect for the iconic rocker-bluesman.
- Winter's posthumously released album, *Step Back*, won a Grammy in 2015.
- He recorded songs written specifically for him by Mick Jagger and Keith Richards ("Silver Train") and John Lennon ("Rock and Roll People").

top and bottom left—
Auditorium Theater, Chicago, IL, 1975

left and right—Auditorium Theater, Chicago, IL, 1974

EDGAR WINTER

multi-instrumentalist, vocalist, bandleader, composer, and arranger

- A multi-instrumentalist who synthesized rock, blues, jazz, funk, gospel, soul, classical, and rhythm & blues at the expense of sure-fire commercial success.
- His music, and the song "Free Ride," in particular, has been used in no less than fifteen national advertising campaigns, television projects, and films.
- The naming of his hit song "Frankenstein" was inspired by Winter's drummer, who compared the process of cutting and splicing many sections of audio tape to the making of Boris Karloff's Frankenstein monster.
- Winter's band, White Trash, was one of the most underappreciated, kick-ass white horn bands ever assembled.
- Next to his brother, Johnny, Ray Charles has had the greatest musical influence on his life.
- Devised the keyboard body strap, which gave him the freedom to roam the stage much like a guitar player.
- Played his first gig in a Texas nightclub at age 11 with his brother in Johnny and the Jammers.

BAD COMPANY

formed 1973; original lineup, 1973–1982: Paul Rodgers (lead vocals, keyboards, guitar, and harmonica), Mick Ralphs (lead guitar, keyboards), Boz Burrell (bass and vocals), and Simon Kirke (drums, vocals)

- The band's name was inspired by a captioned illustration Paul Rodgers came across in a book about Victorian-age morals, not the 1973 movie starring Jeff Bridges, as sometimes rumored.
- Before forming Bad Company, Paul Rodgers and Simon Kirk played with Free, Boz Burrell with King Crimson, and Mick Ralphs with Mott the Hoople.

- Their self-titled debut album was recorded in ten days and went platinum five times while spawning five rock-radio classics.
- Led Zeppelin's manager, Peter Grant, also managed the band from 1973 to 1982. During this period, Bad Company toured the world every two years, leading to road fatigue and the band's initial breakup.
- Rodgers and Ralphs were the band's primary writers and composers.
- The 1975 song "Shooting Star" was inspired by rock music's early drug casualties.
- Rodgers was unaware that surviving Doors' members considered him as Jim Morrison's replacement.

right—Paul Rodgers,
Chicago Stadium,
Chicago, IL, 1976

below, left—Mick Ralphs,
Chicago Stadium,
Chicago, IL, 1976

below, right—Simon
Kirke, Chicago Stadium,
Chicago, IL, 1976

TEN YEARS AFTER

formed 1967; Alvin Lee (guitar, vocals), Leo Lyons (bass), Ric Lee (drums, percussion), and Chick Churchill (piano, organ, synthesizers, and backup vocals)

- Bassist Leo Lyons suggested the band's name after coming across a book about the 1956 Suez Canal crisis, titled *Suez: Ten Years After.*
- For many, the band's Woodstock performance of "I'm Going Home" was the concert film's highlight.
- Lee's heavily stickered stage guitar (nicknamed Big Red) featured a Woodstock sticker he acquired during the event. He picked up the peace sticker at a 1967 Filmore West gig.
- Bassist Leo Lyon's "head banging" movements often required the taping of his headphone monitors to his head.
- Alvin said the band's best musician was keyboardist Chick Churchill, who loved playing Beethoven piano sonatas.
- Alvin Lee was tagged with several unwanted nicknames due to his speedy riffing. Among them was "Captain Speedfingers."

top and bottom left—Alvin Lee, International Amphitheater, Chicago, IL, 1975

left and right—Auditorium Theater, Chicago, IL, 1974

TOMMY BOLIN

guitarist, songwriter, keyboardist, and drummer

- Over his short career, Bolin played the blues with Albert King and John Lee Hooker; rock and roll with Chuck Berry; jazz-rock with Billy Cobham and Alphonse Mouzon; gumbo-funk with Dr. John; and hard rock with the James Gang and Deep Purple.
- Bolin's "glam" look was inspired by David Bowie. His appearance and outlandish garb occasionally led to gender misidentification.
- His solo career received a huge lift after playing on Billy Cobham's 1973 landmark fusion album, *Spectrum*.
- Bolin told *Guitar Player* magazine, "Most of the time, I don't know what I'm playing. Kids come up to me and ask me to show them this or that. I really can't. They probably walk away thinking, 'what a jerk.'"[6]
- He couldn't read music or charts, but had a gift for picking up music of almost any style and putting guitar to it.

WISHBONE ASH

formed 1969; classic lineup: Andy Powell (guitar, vocals), Steve Upton (drums), Martin Turner (bass, vocals), and Ted Turner (guitar, vocals)

- Wishbone Ash are known for the melodic and sophisticated interplay between their two lead guitarists.
- Andy Powell remains the only constant throughout the band's 49-year, multiple-lineup odyssey.
- Ash mixed progressive rock, English folk, blues, boogie, and jazz. The band's lyrics drew from mythology, fantasy, and even the Bible.
- Named best new band in 1971 by British publications *Melody Maker* and *Sounds.*
- Deep Purple's Ritchie Blackmore was instrumental in landing Ash a producer and record deal.
- Inspired by a photo of blues great Albert King, Andy Powell favored King's rocket-shaped Gibson Flying V guitar (pictured left).
- Guitarist Ted Turner played on John Lennon's legendary album, *Imagine.*
- Among the first rock bands from the Western world to tour the Soviet Union during the Glasnost era.

top left—Andy Powell, Auditorium Theater, Chicago, IL, 1973

bottom left—Ted Turner, Auditorium Theater, Chicago, IL, 1973

MOTT THE HOOPLE

formed 1969; original members: Ian Hunter (lead vocals, piano, and guitar), Dale "Buffin" Griffin (drums), Peter Overend Watts (bass), Verden Allen (organ), and Mick Ralphs (guitar)

- The band was named after a 1960s underground comic novel by Willard Manus.
- Ian Hunter bluffed his way through a band audition and got the job mostly on his looks.
- Precursors to punk, they connected with working-class kids with their weird looks, swagger, and energetic music-making.
- Queen's Brian May said, "Mott would swing relentlessly and unstoppably into their show every night like a marauding band of outlaws."[7]
- David Bowie was a Mott fan. They rejected his song, "Suffragette City," but recorded "All the Young Dudes."
- They were the first rock act to appear on Broadway.

above—Ian Hunter, Auditorium Theater, Chicago, IL, 1973

top left—Geezer Butler, International Amphitheater, Chicago, IL, 1974

top right—Tony Iommi, International Amphitheater, Chicago, IL, 1974

left—International Amphitheater, Chicago, IL, 1974

BLACK SABBATH

formed 1969; original 1969–1978 lineup: Ozzy Osbourne (lead vocals), Tony Iommi (guitar), Geezer Butler (bass), and Bill Ward (drums)

- Inducted into the U.K. Music Hall of Fame in 2005 and the Rock and Roll Hall of Fame in 2006.
- The band's name and song title were taken from a 1963 Mario Bava horror movie starring Vincent Price.
- To compensate for an industrial accident that removed the tips of two of Tony Iommi's fretting fingers, he fashioned thimble-like extensions and tuned-down his strings to make them less taut.
- Bassist Geezer Butler was the band's primary wordsmith. His lyrics drew heavily from his fascination with the black arts, science fiction, and themes of global annihilation. However, Black Sabbath were not occultists.
- The nickname "Ozzy" (short for Ozzy-brain) originated with grammar school classmates who made fun of his learning disabilities. The Beatles inspired him to become a singer and escape a depressing childhood.

- Scott Ian of Anthrax remarked, "What are my top five metal albums? I make it easy and always cite the first five Sabbath albums."[8]
- Black Sabbath's first five albums achieved platinum or greater sales status. *Time* magazine called the band's album, *Paranoid*, "the birthplace of heavy metal."[9]
- The band's 1983 Born Again tour served as material for Rob Reiner's hilarious 1984 mockumentary, *Spinal Tap*.

right—Ozzy Osbourne, International Amphitheater, Chicago, IL, 1974

ERIC CLAPTON
guitarist, singer, songwriter, and bandleader

- The Rock and Roll Hall of Fame's only triple inductee (Yardbirds, Cream, solo artist).
- B.B. King: "He's a real English gentleman. He's the kind of person the world needs more of—not only as a musician, but as a man. I love the guy."[10]
- In 2014, Clapton's coveted 1973–1985 stage guitar, "Blackie" (pictured left), auctioned for a record-setting $959,500.
- A 2015 *Rolling Stone* magazine panel of top guitarists and experts voted Clapton second in its "100 Greatest Guitarists" issue.
- Producer Tom Dowd said about the album, *Layla:* "There had to be some telepathy going on [between Eric and Duane Allman], because I've never seen spontaneous inspiration happen at that rate and level."[11]

top left—International Amphitheater, Chicago, IL, 1974

bottom left—Eric with Yvonne Elliman, International Amphitheater, Chicago, IL, 1974

B.B. KING

guitarist, singer, songwriter, and bandleader

- Universally recognized as the most accomplished practitioner and ambassador of post-World War II blues.
- His career spanned seven decades, 100 albums, 15 Grammy Awards, 88 countries played, numerous Hall of Fame inductions, and other honors.

- Once a disc jockey for a Memphis radio station, "B.B." was an abbreviation for his on-air moniker, "Beale Street Blues Boy."
- "King's trademark hand vibrato was an attempt to mimic the sound of Cousin Bukka White's bottleneck guitar and Hawaiian music.
- King once explained, "I'm trying to get people to see that we are our brother's keeper. Red, white, black, brown, yellow, rich, poor . . . we all have the blues."[12]

right—Kinetic Playground, Chicago, IL, 1973

JEFFERSON STARSHIP

formed 1974; classic lineup: Paul Kantner (rhythm guitar, vocals), Grace Slick (vocals, keyboards), Marty Balin (vocals, guitar), "Papa" John Creach (violin), David Freiberg (bass, keyboards, and vocals), Craig Chaquico (lead guitar, vocals), John Barbata (drums), and Pete Sears (bass, keyboards, guitar, and vocals)

- Jefferson Starship descended from Rock and Roll Hall of Fame band, Jefferson Airplane.
- The name Jefferson Starship first appeared on the Jefferson Airplane-era concept album, *Blows Against the Empire*.
- Original member Paul Kantner was part of both bands for nineteen consecutive years.
- Grace Slick was one of the first female rock stars. She was a former department-store model and student at New York's Finch College for women.
- Violinist "Papa" John Creach began his career playing in Chicago bars in the 1930s.
- Their highest-charting single was the ballad, "Miracles," featuring Marty Balin's exquisite vocals.

top left—Grace Slick, Auditorium Theater, Chicago, IL, 1974

bottom left—"Papa" John Creach, Auditorium Theater, Chicago, IL, 1974

above—Auditorium Theater, Chicago, IL, 1974

JOHN SEBASTIAN

singer, songwriter, harmonica, guitar, and autoharp

- One of the best modern-day ambassadors of American roots music.
- As a member of The Lovin' Spoonful, Sebastian was elected to the Rock and Roll Hall of Fame in the year 2000 and the Songwriters Hall of Fame in 2008.
- From 1965–1967, The Lovin' Spoonful had seven consecutive Top 10 hits.

- Sebastian wrote the catchy theme for the *Welcome Back Kotter* TV series in under 30 minutes.
- Has lent his music in support of social, environmental, and animal rights causes.
- Sebastian played blues harp on the Doors' song, "Roadhouse Blues," and harmonica on the Crosby, Stills, Nash and Young song, "Déjà Vu."
- He wrote "Do You Believe in Magic" after watching a pretty girl dancing "free form" during a Spoonful gig.

JOE COCKER

singer and bandleader

- Cocker parlayed his raspy, righteous-sounding voice and eccentric stage presence into four decades of international stardom.
- He made a career of interpreting other people's songs and making them his own. A prime example was the Beatles' hit, "With a Little Help from My Friends."
- His spasmodic stage movements were considered too risqué for a 1969 appearance on the *Ed Sullivan Show*. He was partially hidden from audience view.
- Cocker formed The Grease Band in 1966 and played a rousing 85-minute set at the 1969 Woodstock Music and Arts Festival.
- In 1970, he joined forces with Leon Russell and formed Mad Dogs and Englishmen, a rock and soul conglomerate of around 40 musicians, crew, wives, girlfriends, children, and hangers-on.
- His album, *With a Little Help from My Friends*, had help from Jimmy Page, Steve Winwood, and Chris Stainton.

left—Auditorium Theater, Chicago, IL, 1974

above—Chicago Stadium, Chicago, IL, 1973

LEON RUSSELL

pianist, guitarist, singer, songwriter, and composer

- Russell was a member of the esteemed Wrecking Crew, a group of Los Angeles session musicians who played on countless pop hits during the 1960s.
- Inducted into the Rock and Roll Hall of Fame and Country Music's Songwriters Hall of Fame.
- Co-founded Shelter Records, the early recording home to Tom Petty, Phoebe Snow, Dwight Twilley, and others. His label helped revive the career of blues great Freddie King.
- Russell served as bandleader and pianist for George Harrison's 1971 all-star benefit, the Concert for Bangladesh. He served as musical director and pianist for Joe Cocker's 1970 *Mad Dogs and Englishmen* tour and film.
- A forgotten man late in his career, Elton John restored Russell's reputation through several laudatory public statements. In 2010, the two recorded *The Union*, and a documentary followed.

ELVIS PRESLEY

singer and actor

- The only musician to be inducted into three music halls of fame.
- Presley acted in 31 films and two documentaries.
- With record sales estimated at over $1 billion worldwide, Elvis is the top-selling artist of all time.
- In 1965, Elvis, John Lennon, and Paul McCartney had an impromptu jam session at Presley's Bel-Aire home.
- Long-time manager, Colonel Tom Parker, was born in the Netherlands and entered the United States illegally. He told people he hailed from West Virginia.
- Elvis was drafted by the Army in 1958. While stationed in Germany, he met his future wife, Priscilla, who was the teenage daughter of an Air Force officer.
- His 1973 performance, "Elvis: Aloha from Hawaii," was broadcast via satellite to 40 countries and viewed by an estimated 1.5 billion people. It was watched by more American households than the first moon walk.

- In 1987, Priscilla Presley opened Graceland to the public. It averages 600,000 visitors annually and brings $100 million into the local Memphis economy.
- The mansion was built in 1939 by a doctor and his wife, who named it after his wife's aunt, Grace, the original landowner.
- His 1968 televised "Comeback Special" was the most watched show of the season, re-launching his singing career and his return to performing in concert.
- The "Memphis Mafia" was a close-knit crew who protected Elvis and served as confidants.
- Five Presley recordings are in the prestigious National Academy of Recording Arts and Sciences Hall of Fame: "Hound Dog," "Heartbreak Hotel," "That's All Right," "Suspicious Minds," and "Don't Be Cruel."
- A record 131 albums and singles have been certified Gold, Platinum, or Multi-Platinum.

previous page, this page—Chicago Stadium, Chicago, IL, 1976

left and right—Steven Tyler, Auditorium Theater, Chicago, IL, 1973

AEROSMITH

formed 1970; Steven Tyler (lead vocals, harmonica), Joe Perry (guitar), Brad Whitford (guitar), Tom Hamilton (bass), and Joey Kramer (drums)

- "Aerosmith sound like the Yardbirds, Led Zeppelin and the Rolling Stones having a battle of the bands at a low-key dive bar." —Rock and Roll Hall of Fame[13]
- The second best-selling American rock band measured in U.S. album sales.
- Aerosmith were the winners of over two dozen American Music, Billboard Music, Grammy, MTV Video Music, People's Choice, Soul Train Music, and other category awards.
- After a period of professional and personal decline, producer extraordinaire, Rick Rubin, brought the band and hip-hop superstars Run-DMC together to record a 1986 rock-funk-rap remake of "Walk This Way." It led to a new wave of popularity and success for the Boston-based quintet.
- Rock and Roll Hall of Fame inductees (2001).
- The 1987 song, "Dude (Looks Like a Lady)" was inspired by Mötley Crüe's singer, Vince Neil. While at a bar with his back turned, bandmembers mistook him for a "hot blond."

MONTROSE

formed 1973; Ronnie Montrose (guitar), Sammy Hagar (lead vocals), Bill Church (bass), Denny Carmassi (drums), and Alan Fitzgerald (bass)

- Founded by lead guitarist, Ronnie Montrose, who initially produced his coveted, bone-crushing guitar tone from a small Fender amp purchased at a yard sale for $90.
- The band's crotch-rock anthems were a precursor to the sound of American metal and "hair" bands that followed in the late 1970s and 1980s.
- Ronnie played on Edgar Winter's timeless rock classics "Free Ride" and "Frankenstein." He also worked with Van Morrison, jazzmen Herbie Hancock and Tony Williams, Boz Scaggs, Gary Wright, The Neville Brothers, and Paul Kantner.
- Known as the "Red Rocker," Hagar followed with a successful solo career and Van Halen.
- After leaving Montrose, Carmassi played with Heart, Jimmy Page, Joe Walsh, and others.

left—Ronnie Montrose, Auditorium Theater, Chicago, IL, 1974
right—Sammy Hagar, Auditorium Theater, Chicago, IL, 1974

GOLDEN EARRING

formed 1961; classic lineup: George Kooymans (guitar, vocals), Rinus Gerritsen (bass, keyboards), Barry Hay (guitar, vocals, flute, saxophone), and Cesar Zuiderwijk (drums, percussion)

- The Netherlands' most successful and longest-lived rock band export. ZZ Top is the only band that has performed longer and continuously with the same lineup.
- The name Golden Earring was derived from a 1947 World War II film staring Ray Milland and Marlene Dietrich.
- The band had eight number-one albums in their homeland, but only two (*Moontan* in 1973 and *Cut* in 1982) broke into the top 100 in the United States.
- Their biggest U.S. hits were "Radar Love," "Twilight Zone," and "Quiet Eyes."
- In 2007, a space shuttle crew member requested "Radar Love" as his wakeup song. The song was also used to "wake up" the Mars explorer vehicle.
- Originally named The Tornadoes until learning of a British band of the same name who scored the 1962 hit instrumental, "Telstar."
- Opened for Delaney, Bonnie and Friends (with Eric Clapton) on their first U.S. tour in 1969.

top left—Barry Hay, Auditorium Theater, Chicago, IL, 1974

bottom left—George Kooymans, Auditorium Theater, Chicago, IL, 1974

HEART

formed 1973; classic lineup: Ann Wilson (vocals, guitar, and flute), Nancy Wilson (vocals, guitar, and mandolin) Roger Fisher (guitar), Howard Leese (keyboards, guitar, and mandolin), Steve Fossen (bass), and Michael DeRosier (drums)

- Heart was the first female-fronted rock band to hit the big time, with seven multi-platinum albums and twenty Top 10 singles.
- The Wilson sisters repeatedly encountered sexism. Ann recalled, "It took a long time for us to be taken seriously . . . to find so-called credibility, especially among the rock press. I remember hearing someone say, 'That Nancy is a fine-looking girl, but is that guitar really plugged in?'"[14]
- Inducted into the Rock and Roll Hall of Fame in 2013.
- The song "Barracuda" was Ann's angry response to a publicist's stunt suggesting she and her sister were lovers.
- Singing helped Ann Wilson overcome a childhood speech impediment.
- Heart's "Stairway to Heaven" performance at the 2012 Kennedy Center Honors received 5 million YouTube hits the first week. The lineup featured Jason Bonham (John's son) on drums.
- Nancy Wilson has composed music for several films, including *Almost Famous* and *Vanilla Sky*.

top right—Ann Wilson, International Amphitheater, Chicago, IL, 1978

bottom right—Nancy Wilson, International Amphitheater, Chicago, IL, 1978

above—Rod Stewart and Ron Wood, Chicago Stadium, Chicago, IL, 1975

FACES

formed 1969; Rod Stewart (lead vocals), Ronnie Wood (guitar, vocals), Ronnie Lane (bass, vocals), Kenney Jones (drums), and Ian McLagan (keyboards)

- The Faces and their predecessors, the Small Faces, were inducted into the Rock and Roll Hall of Fame in 2012. The "Small" was dropped when diminutive guitarist, Steve Marriot, was replaced by the taller Ronnie Wood and Rod Stewart.
- Between 1969 and 1975, The Faces made some of the most endearing, rollicking, occasionally ragged but quintessentially British rock and roll ever made.

- Before joining the Faces, Rod Stewart played with future Fleetwood Mac founders Peter Green (guitar) and Mick Fleetwood (drums). He also sang lead vocals on the first two Jeff Beck Group LPs.
- The Faces' best-known U.S. single was "Stay with Me." Tangential to the band, Stewart launched a highly successful solo career.
- Ronnie Lane's vocals and songwriting were the heart and soul of the band. He departed in 1973 for a solo career after feeling like a sideman to Stewart's dominating vocals.
- In 1975, guitarist Ronnie Wood famously replaced Mick Taylor in The Rolling Stones.
- Keyboardist Ian McLagan became an in-demand journeyman for studio and tour work.

above—Ronnie Wood, Chicago Stadium, Chicago, IL, 1975 above—Rod Stewart, Chicago Stadium, Chicago, IL, 1975

right—
Rod Stewart and
Ronnie
Wood,
Chicago
Stadium,
Chicago,
IL, 1975

RORY GALLAGHER

guitarist, singer, and songwriter

- A master of both electric and acoustic guitar who sang like people's lives depended on it.
- The Irish native developed an international grass roots following due to his rigorous touring and strong work ethic.
- Admirers included Jimi Hendrix, Brian May, John Lennon, Eric Clapton, Bob Dylan, Johnny Marr, The Edge, Slash, Gary Moore, and Joe Bonamassa.
- Formed the neo-Cream power trio, Taste, at age 17. The band supported Cream at their 1968 farewell concert at London's Royal Albert Hall.
- Toured the United States 25 times and appeared at the Montreux Jazz Festival more times than any other act.
- When most acts shunned Belfast, Northern Ireland, during its violent years, Gallagher performed there regularly, inspiring young Irish fans and musicians.

top and bottom left—
Beginnings, Schaumburg, IL, 1974

left—Steve Marriott and Dave "Clem" Clempson, International Amphitheater, Chicago, IL, 1973
right—Steve Marriott, International Amphitheater, Chicago, IL, 1973

HUMBLE PIE

formed 1969; Steve Marriott (guitar, vocals, harmonica, and keyboards), Peter Frampton (guitar, vocals, and keyboards), Greg Ridley (bass, guitar, and vocals), Jerry Shirley (drums, percussion, and keyboards), and Dave "Clem" Clempson (guitar, vocals, and keyboards; replaced Peter Frampton in 1971)

- Known for their brand of heavy-metal blues crunch. Eventually, Marriott brought soul, gospel, and rhythm and blues into the sound mix.

- The band's name was meant to infer equality among band members.
- Marriot first reached pop stardom as a member of the Small Faces.
- Frampton began with the British band, The Herd. After leaving Pie, he became one of the biggest arena rock stars of the 1970s.
- Marriott was Keith Richard's initial choice to replace Rolling Stones guitarist, Mick Taylor, but only if the impudent musician promised not to upstage Mick Jagger.

JETHRO TULL

formed 1967; key members 1968–1975: Ian Anderson (vocals, flute, and guitar), Martin Barre (guitar), Glenn Cornick (bass), Clive Bunker (drums), John Evan (keyboards), Jeffrey Hammond-Hammond (bass), and Barriemore Barlow (drums)

- Tull began as a Brit-style blues band reminiscent of early Cream.
- From their second album onward, Tull became more musically complex and closely identified with Ian Anderson's breathy flute solos, Dickensian stage garb, and unmistakable vocals.

- Martin Barre played with Tull for 43 years. The Grammy-winning guitarist transitioned the band's quieter passages into hard-rock territory.
- Anderson's lyrics were a metaphoric vehicle for his humorous and sardonic views on society and personal matters.
- *Thick as a Brick* was the first rock album to feature one continuous song on both sides.
- Before settling on the name Jethro Tull (a 19th century English architectural pioneer), the band regularly changed names to get re-booked into venues where they had performed poorly.

PROCOL HARUM

formed 1967; select members through 1976: Gary Brooker (composer, vocals, and piano), Keith Reid (lyrics), Matthew Fisher (composer, organ), David Knights (bass), Robin Trower (guitar), B.J. Wilson (drums), Chris Copping (organ, bass), Alan Cartwright (bass), and Mick Grabham (guitar)

- Procol Harum was one of the pioneers of the neo-classical rock movement.
- Gary Brooker was the band's chief song composer, and Keith Reid its lyricist. The band was one of the first rock groups to employ both an organist and pianist onstage.
- Brooker, Reid, and Fisher wrote "A Whiter Shade of Pale." It was based on a Bach Suite, with the sound and feel of the Percy Sledge classic, "When a Man Loves a Woman." The 1967 song reached number one in multiple countries and was inducted into the Grammy Hall of Fame.

top—Chris Copping, Auditorium Theater, Chicago, IL, 1975

bottom—B.J. Wilson, Auditorium Theater, Chicago, IL, 1975

JOE WALSH

guitarist, singer, and songwriter

top and above—Auditorium Theater, Chicago, IL, 1975

- Known for his work with The James Gang, Barnstorm, The Eagles, and as a solo artist.
- Inducted into the Rock and Roll Hall of Fame as a member of the Eagles.
- Walsh considers himself a third-generation blues devotee of B.B. King, Eric Clapton, Mick Taylor, and Peter Green. His slide guitar technique and tone evoke memories of the late, legendary Duane Allman.
- Pete Townshend's trademark rhythm and lead technique heavily influenced Walsh during a 1970 James Gang tour with The Who.
- Walsh is known for his sense of humor, charm, and down-to-earth demeanor, which endears him to fans and peers alike. He has contributed his time and money to a variety of humanitarian causes.
- Walsh's solo hit, "Life's Been Good," speaks volumes about the musician and his career.

above and below—Ray Davies, Auditorium Theater, Chicago, IL, 1973

THE KINKS

formed 1963; original lineup: Ray Davies (lead vocals, piano, and rhythm guitar), Dave Davies (lead guitar, vocals), Peter Quaife (bass, backing vocals), and Mick Avory (drums, vocals)

- One of the most important British Invasion bands.
- Entered the Rock and Roll Hall of Fame in 1990.
- Infighting between brothers Ray and Dave was the stuff of legend.
- The name Kinks was intended to create controversy.
- Ray dipped into his English roots and became the quintessential chronicler of English life. His sardonic humor and social satire were evident in many songs.

- Charles Shaar Murray on Dave Davies' guitar playing: "He's still capable of playing like a kid who's just plugged in his first electric guitar and wants the people on the next street to know about it."[15]

NEW YORK DOLLS

formed 1971; debut album lineup: David Johansen (lead vocalist), Johnny Thunders (guitar, bass, and vocals), Arthur "Killer" Kane (bass), Sylvain Sylvain (rhythm guitar), and Jerry Nolan (drums)

- The New York Dolls paved the way for punk rock, new wave, and glam bands.
- The band's name was derived from a New York toy repair shop called the Doll Hospital.
- Sylvain Sylvain remarked, "So many critics, as well as musicians, said we sucked! That we couldn't play, couldn't sing, and couldn't dance sideways much less backwards in high heels."[16]

- About their sound, Joe Matera of *Classic Rock* wrote, "Whatever the band lacked in proficiency and sophistication, they more than made up for in attitude and bare-bones rock and roll rawness that spoke the same language of disenchanted youth everywhere."[17]
- In 1987, Johansen scored the hit single "Hot, Hot, Hot" under the pseudonym Buster Poindexter.
- A *Creem* magazine reader poll once voted them both best and worst band of the year.
- Their first gig took place on Christmas Eve, 1971, in a homeless shelter.

left—David Johansen, Auditorium Theater, Chicago, IL, 1973
right—Johnny Thunders, Auditorium Theater, Chicago, IL, 1973

left—Dave Hill, Auditorium Theater, Chicago, IL, 1973
right—Noddy Holder, Auditorium Theater, Chicago, IL, 1973

SLADE

formed 1966: Noddy Holder (lead vocalist, co-songwriter), Dave Hill (guitar, vocals), Jim Lea (bass, keyboards, violin, and co-songwriter), and Don Powell (drums)

- From the period 1971 through 1975, Slade ruled the U.K. singles and record charts.
- Their sound featured Holder's raspy, powerful tenor vocals, infectious pop hooks, a ferocious rhythm section, and thick, dirty-sounding rhythm guitars.
- Their best-selling U.K. song, "Merry Xmas Everybody," has re-entered the U.K. charts over a dozen times.
- The band deliberately misspelled words in their lyrics and song titles. It was a nod to their roots—the Black Country region of England known for a dialect containing phonetic spelling peculiarities.
- Their manager was Chas Chandler of the Animals (bassist) and Jimi Hendrix (manager) fame.

THE WHO

formed 1964; Pete Townshend (guitar, keyboards, and vocals), Roger Daltrey (lead vocals, harmonica), John Entwistle (bass, horn arrangements, vocals), and Keith Moon (drums)

- Their early music was aimed at England's "Mods," a youth culture identified by its clean-cut look, trendy clothes, scooters, amphetamine use, and love of Motown music.

- Townshend's penchant for destroying guitars came about by accident after damaging his guitar's headstock against a low-hanging tavern ceiling. Out of frustration, he smashed what remained. At their next show, Keith Moon followed suit by wrecking his drum kit.
- The first rock band to seriously integrate keyboard synthesizers into their music.
- The song "Who are You" was Townshend's snide commentary on Britain's punk music craze.

top right—Roger Daltrey, Chicago Stadium, Chicago, IL, 1975

bottom right—Keith Moon, Chicago Stadium, Chicago, IL, 1975

- In 1967, Roger Daltrey broke 18 microphones during a nine-show engagement in New York City. He was known for swinging his microphone with controlled but wild abandon.
- Townshend's well-publicized hearing loss began on a Smothers Brothers television show after Moon's drum kit, packed with explosives, detonated at high volume.
- Lifetime Achievement awards from the Grammy Foundation in 2001 and the British Phonographic Industry (BPI) in 1988.
- Having lost five years of royalties due to early legal matters, The Who were forced to tour endlessly. As a result, they became one of rock's most exciting live bands.
- *Musician* magazine voted John Entwistle "Best Bassist of the 20th Century."

- From 1976 to 1986, *The Guinness Book of Records* listed The Who as the world's loudest rock band.
- Eleven deaths at a 1979 Who concert in Cincinnati led to changes in the practice of unreserved arena seating.
- At Woodstock, the band refused to perform until a promoter brought them a certified check.
- The song "My Generation" was ranked as the 11th Greatest Rock and Roll Song by *Rolling Stone* magazine. In 1999, it was selected for preservation in the U.S. National Recording Registry.
- Keith Moon, one of rock's greatest drummers, adopted the peculiar style of pointing his drumsticks downward.

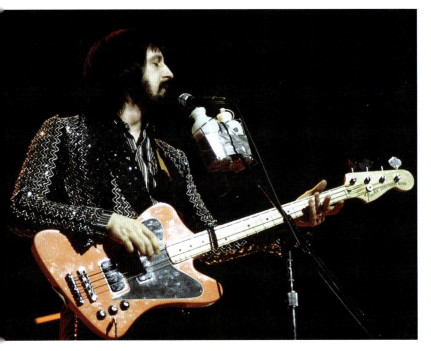

top left—The Who, Chicago Stadium, Chicago, IL, 1975

bottom left—John Entwistle, Ox Tour, Chicago Auditorium, Chicago, IL, 1975

FRANK ZAPPA

guitar, synclavier, bandleader, songwriter, composer, arranger, and free speech advocate

- The only artist to be inducted into the Rock and Roll and Jazz Halls of Fame.
- Awarded a Grammy Lifetime Achievement Award in 1997.
- His earliest influences included the complex sounds of modern-era composers Edgard Varese, Igor Stravinsky, and Anton Webern.

- His catalog of music recordings is one of the largest (roughly 100 albums) to date.
- Zappa's Mothers of Invention band was among the first rock groups to stage mixed-media shows called "Freak-Outs." They set new standards for performance.
- *Apostrophe* was Zappa's only Top 10 Billboard album, and the novelty song "Valley Girl" his only Top 40 single.
- Zappa's family copyrighted his signature facial hair look: thick droopy mustache and soul patch.

right—Northern Illinois University, Dekalb, IL, 1974

ROBIN TROWER BAND

Robin Trower (electric guitar, song-writer, and bandleader) James Dewar (bass, vocals, songwriter), Reg Isadore (drums [original]), and Bill Lorden (drums)

- Often compared to Jimi Hendrix, Robin Trower mixed soul, funk, blues, and rock to create a legacy of his own.
- He told Douglas Noble of *Guitar Magazine*, "To be spoken in the same breath or sentence as Hendrix was a great thing, you know! At the same time, I felt people were missing what I was doing because they couldn't see beyond it."[18]
- Trower discovered the musicality of the Fender Stratocaster after fiddling with Martin Barre's instrument during a tour with Jethro Tull.
- Dewar's smoky, mournful vocals conveyed a sense of mood, mystery, and otherworldliness. He remained by Trower's side until the early 1980s.

top left—Robin Trower, Auditorium Theater, Chicago, IL, 1973

bottom left—Reg Isidore, Auditorium Theater, Chicago, IL, 1973

bottom right—James Dewar, Auditorium Theater, Chicago, IL, 1973

left—Pete Way, International Amphitheater, Chicago, IL, 1978
right—Michael Schenker, International Amphitheater, Chicago, IL, 1978

UFO

formed 1969; classic lineup: Phil Mogg (lead vocals), Andy Parker (drums), Pete Way (bass), Paul Raymond (keyboards, rhythm guitar, vocals), and Michael Schenker (guitar)

- Journalist Joel Reese wrote, "At the height of their mid-1970s heyday, this hard-living, ass-kicking, spandex-wearing quintet rocked like few have dared to rock, even if few dared to rock alongside them."[19]

- The band took its name from a London nightclub.
- UFO's first three albums were mostly unknown in the U.S and U.K. In 1973, the Scorpions' Michael Schenker filled in for UFO's then-missing guitarist, and the band's fortunes changed.
- The German-born Schenker was only eighteen years old and barely able to speak English when he joined UFO.
- *Strangers in the Night* is considered one of the greatest live rock albums of all time.

left—Chris Squire, International Amphitheater, Chicago, IL, 1974
right—Steve Howe, International Amphitheater, Chicago, IL, 1974

YES

formed 1968; classic lineup: Jon Anderson (lead vocals, other instruments), Chris Squire (bass, vocals), Bill Bruford (drums, percussion), Steve Howe (guitars, other stringed instruments, and vocals), Rick Wakeman (keyboards), and Alan White (drums, percussion)

- One of progressive rock's founding fathers who found an audience among those weary of standard rock and pop conventions.
- Rick Wakeman's stacks of keyboards were a Yes concert attraction.
- Original drummer Bill Bruford defected to prog rock rival King Crimson in 1972. Alan White, who played on John Lennon's album, *Imagine*, replaced him.
- The 1972 album, *Close to the Edge*, was ranked the best progressive rock studio album ever by the website Prog Archives.
- Chris Squire was part of every Yes lineup until his death in 2015.
- The band was admitted to the Rock and Roll Hall of Fame in 2017.
- Approximately 20 members from five different countries have been part of the band's lineup.
- The Yes name originated with original guitarist Peter Banks. Bandmembers were seeking a short and easy-to-remember moniker.

EMERSON, LAKE AND PALMER

formed 1970; Keith Emerson (piano, organ, synthesizer, and composer) Greg Lake (bass, guitar, songwriter, vocals, and producer), and Carl Palmer (drums, percussion)

- A power trio and bona fide supergroup in which keyboards and percussion, rather than guitars, ruled. With their enormous stage rigs, Emerson and Palmer were the showmen.
- The band introduced a generation of rockers to high-brow composers like Modest Mussorgsky, Alberto Ginastera, and Aaron Copeland.
- Emerson was a pioneering user of Robert Moog's invention, the Moog synthesizer.
- Carl Palmer's use of synthesized percussion was groundbreaking.
- Greg Lake's gorgeous acoustic ballads, versatile vocal range, and painstaking production gave ELP broad commercial appeal.
- "The show that never ends" did. In 1979, the band collapsed under the weight of costly and physically draining tours and diverging musical interests.

above—Keith Emerson and Greg Lake, International Amphitheater, Chicago, IL, 1973

GENESIS

formed 1967; classic lineup: Mike Rutherford (bass, guitar), Peter Gabriel (lead vocals, flute, and percussion), Tony Banks (keyboards, guitar), Phil Collins (drums, lead vocals), and Steve Hackett (guitar)

- Tony Banks, Peter Gabriel, Mike Rutherford, and Anthony Phillips founded the band while attending an exclusive English boarding school.
- Genesis had two distinct songwriting and stagecraft personalities: The artsy Peter Gabriel era (1967–1975) and the mass-appeal Phil Collins era (1975–1996).
- Due to a misleading title and graphics, their debut album, *Genesis to Revelation,* was mistakenly filed in the religious section of many record stores. It sold a mere 600 copies!
- Band members wrote every song on their fifteen studio albums.
- In 2010, the band was symbolically put to rest with their Rock and Roll Hall of Fame induction.
- Phil Collins began his acting career at age 14. He debuted on-screen as an extra in the Beatles' *Hard Day's Night.*
- It took 22 years before bandmembers' faces appeared on an official Genesis album *(The Way We Walk, Volume 1).*

left, top and bottom—Peter Gabriel, Auditorium Theater, Chicago, IL, 1974

HAWKWIND

formed 1969; classic lineup 1971–1975: Dave Brock (guitar, vocals, keyboards, and bass), Nik Turner (sax, flute, electronics, and vocals), Simon King (drums), Robert Calvert (poet, narrator, and vocals), Dik Mik Davies (electronics, synthesizer, and engineer), and Lemmy Kilmister (bass, vocals)

- An eccentric, underground English band that incorporated elements of acid-jazz, hard-rock, house, techno, rave light shows, science fiction, and performance art to create their psychedelic space-rock.
- There were a dizzying array of personnel changes over the band's 50 years. Founding member David Brock has been the one constant and owns the Hawkwind name.
- Band members, dancers, and equipment were positioned on stage according to astrological theories and sound wave science.
- Sid Vicious once said that without Hawkwind, there would be no Sex Pistols.
- Nick Turner, a technically challenged saxophonist, was encouraged by free jazz players in Berlin to focus on expression over proficiency.
- Lemmy Kilmister served as a Jimi Hendrix roadie. He auditioned for Hawkwind as a guitarist, but switched to bass. His future band, Motorhead, was named after the last song he wrote for Hawkwind.

top right—Lemmy Kilmister, Auditorium Theater, Chicago, IL, 1973

bottom right—Nik Turner, Auditorium Theater, Chicago, IL, 1973

KING CRIMSON

formed 1969; debut album members: Robert Fripp (guitar, Mellotron), Michael Giles (drums, vocals), Greg Lake (bass, vocals), Ian McDonald (keyboards, Mellotron, sax, flute, and clarinet), and Peter Sinfield (lyricist, light show, and spoken word)

- *Rolling Stone* magazine once called their sound "brainy gothic metal."
- Robert Fripp is the only member to be part of every lineup. No lineup lasted more than one album until 1982.
- In 1969, the band released their epochal debut album, *In the Court of the Crimson King.* With its neo-gothic artwork, the album cover remains one of rock's most recognizable.
- The song "21st Century Schizoid Man" was Fripp's interpretation of Jimi Hendrix playing Stravinsky's "Rite of Spring."
- Kurt Cobain called the band's 1974 album, *Red,* a seminal influence on his music.

top left—Robert Fripp, Auditorium Theater, Chicago, IL, 1973

bottom left—John Wetton, Auditorium Theater, Chicago, IL, 1973

TODD RUNDGREN

multi-instrumentalist, singer-songwriter, bandleader, arranger, producer, engineer, and music technology pioneer

- Nicknamed "Runt," this rock and roll nonconformist has been hailed as a gifted pop singer/songwriter, studio wizard, accomplished musician, and prolific music-maker who has released several dozen albums and hit songs covering a gamut of genres.
- In addition to an extensive solo career, Rundgren's bands included Nazz, Runt, and notably, Utopia, where he refocused his efforts on guitar-playing.
- The double LP, *Something/Anything*, is his critically acclaimed masterpiece. Rundgren wrote, arranged, sang, produced, engineered, and played every note on three album sides.
- Rundgren, a musical chameleon, remarked, "I guess you could say I'm like a Casanova of music. I can't seem to settle down with one musical form."[20]

right—Arie Crown Theater, Chicago, IL, 1973

MOODY BLUES

formed 1964; classic albums period: Mike Pinder (keyboards, vocals), Ray Thomas (flute, harmonica, percussion, vocals), Graeme Edge (drums), John Lodge (bass, vocals), and Justin Hayward (guitar, vocals)

- Among the first rock groups to make significant use of the Mellotron keyboard. Mike Pinder recalled, "I will never forget seeing and playing [it] for the first time. This was my 'first man on the moon'

right—John Lodge, Chicago Stadium, Chicago, IL, 1973

bottom left—Mike Pinder, Chicago Stadium, Chicago, IL, 1973

bottom right—Justin Hayward, Chicago Stadium, Chicago, IL, 1973

event. I knew that my life had led to this moment, the portent to the future."[21]

- Fame came quickly with their 1965 number-one single, "Go Now." A temporary descent followed. In 1967, their fortunes changed with a musical makeover and release of the innovative concept album, *Days of Future Passed*, and the songs "Nights in White Satin" and "Tuesday Afternoon."

- Misguided fans read too deeply into their music and lyrics. In response, John Lodge wrote the song, "I'm Just a Singer in a Rock and Roll Band."

- From 1967 through 1972, they entered their classic albums period, with seven highly successful releases and a bevy of rock radio classics.

- Known for their orchestrated fusion of pop, folk, and mystical rock along with profound lyrics, striking melodies and four-part vocals.

- They were inducted into the Rock and Roll Hall of Fame in 2018.

right—Ray Thomas, Chicago Stadium, Chicago, IL, 1973

DAVE
MASON

singer, songwriter, composer, guitarist, bass, and bandleader

- Mason was a member of the Rock and Roll Hall of Fame band, Traffic, and an original (albeit brief) member of Eric Clapton's Derek and the Dominos prior to the release of the album, *Layla*.
- His vocals and instrumentation can be heard on recordings by Jimi Hendrix, Delaney and Bonnie, Crosby and Nash, Stephen Stills, Paul McCartney, George Harrison, the Rolling Stones, and even a Miller beer radio commercial.
- Songwriting credits include easy rockers and ballads such as "Feelin' Alright," "Show Me Some Affection," and "Only You Know and I Know."
- Received his first sitar from George Harrison.
- Michael Jackson sang on Mason's "Save Me" from the 1980 album, *Old Crest on a New Wave*.

top left—Auditorium Theater, Chicago, IL, 1975

bottom left—Auditorium Theater, Chicago, IL, 1974

TRAFFIC

formed 1967; original members: Steve Winwood (keyboards, guitar, bass, and vocals), Chris Wood (reed instruments, organ, and vocals), Jim Capaldi (drums, percussion, and vocals), and Dave Mason (guitar, sitar, Mellotron, and vocals)

- Traffic's music jumped genres from whimsical, English folk-pop, to rhythm and blues, to jazz-flavored rock jams.
- Jim Capaldi thought up the band's name as he was waiting to cross a busy street.
- At age fifteen, Winwood played and sang for the Spencer Davis Group. His soulful, Ray Charles-like voice was mature beyond his years.
- Winwood joined Eric Clapton, Ginger Baker, and Ric Grech in the short-lived supergroup, Blind Faith.
- Known best for his song-writing, keyboards, and vocals, Winwood is a skillful guitarist.
- Mason would leave Traffic over disagreements with members about artistic direction and other matters.

top right—Steve Winwood, Auditorium Theater, Chicago, IL, 1974

bottom right—Chris Wood, Auditorium Theater, Chicago, IL, 1974

STEPHEN STILLS

singer, songwriter, guitar, bass, keyboards, arranger, and bandleader

above—Arie Crown, Chicago, IL, 1974

- The only musician to be inducted into the Rock and Roll Hall of Fame twice on the same night as a member of Buffalo Springfield and Crosby, Stills and Nash.
- His 1970 solo debut album, *Stephen Stills*, is the only LP to have both Eric Clapton and Jimi Hendrix as guest artists. Stills said, "Hendrix was a wonderfully kind and generous man who tried to show me lots of things on guitar. Boy, we had some good times."[22]
- Stills is among the few musicians to have played all four of America's most defining music festivals: Monterey Pop, Woodstock, Altamont, and Live Aid.
- Admitting to an abrasive personality early in his career, he told Cameron Crowe, "I have a bad habit of stating things pretty bluntly. I'm not known for my tact."[23]
- Played nearly every instrument on the 1969 Cosby, Stills, and Nash debut album.

PETER FRAMPTON

guitarist, singer, songwriter, and bandleader

- At age 16, Frampton became a British pop sensation with the modish band, The Herd.
- He co-founded the group Humble Pie with guitarist Steve Marriot.
- His 1976 live double LP, *Frampton Comes Alive*, remained at No. 1 for ten weeks and lingered on Billboard's Top 200 chart for 97 weeks. It earned him fame, fortune, and opportunities in advertising, movies, and television.
- One of Frampton's signature guitar effects was the Heil Talk Box. It enabled guitarists to create talking guitar tones through a tube.
- Later in his career, Frampton confessed, "It took so long for me to realize that success isn't measured in how many albums you sell or how many concert tickets people buy, but rather by an internal barometer."[24]
- Frampton's megahit, "Do You Feel Like We Do," pertained to a hangover.
- He was an advisor on Cameron Crowe's motion picture, *Almost Famous* (2000) and had a cameo as manager of his former group, Humble Pie.
- Frampton and David Bowie were classmates at the same technical arts school where Frampton's father was an instructor.
- He regretted the shirtless photo used on the cover of a 1976 issue of *Rolling Stone* magazine because it reinforced his teen idol image.

top and bottom right—Northern Illinois University, DeKalb, IL, 1975

left—Peter Haycock, Auditorium Theater, Chicago, IL, 1973
right—Colin Cooper, Auditorium Theater, Chicago, IL, 1974

CLIMAX BLUES BAND

formed 1968; members of every lineup through 1983: Colin Cooper (vocals, sax, harmonica, and rhythm guitar), Peter Haycock (guitar, vocals), and Derek Holt (guitar, vocals, bass, and keyboards)

- Co-founded by multi-instrumentalist Colin Cooper and guitarist Peter Haycock.
- Originally named the Climax Chicago Blues Band, "Chicago" was dropped following pressure from the band Chicago.
- Inspired by American black music, Cooper and Haycock had hopes of riding the last surge of British blues popularity.

- It took nine albums and eight years before Climax scored its biggest hit single, "Couldn't Get it Right," a song about life on the road.
- Their U.S. breakthrough occurred in 1973 with the double live LP, *FM Live*. Recorded live in New York City and broadcast over FM radio, it showcased the band's muscular jazzy-blues.
- Peter Haycock left the band for a solo and film score career that included Electric Light Orchestra 2, Night of the Guitar, Guitar and Son, and films like *Thelma and Louise* and *K2*.

J. GEILS BAND

formed 1967; J. Geils (guitar), Peter Wolf (lead vocals), Magic Dick (harmonica, saxophone, and trumpet), Danny Klein (bass), Seth Justman (keyboards, vocals), and Stephan Jo Bladd (drums, vocals)

- Called the "Jewish Rolling Stones" in their early playing days. All were Jewish, except Geils.
- Endless touring helped them build a large following based on their funky brand of blues-rock and party anthems like "First I Look at the Purse" and "Whammer Jammer."
- Success came later, with hits like "Centerfold," "Freeze Frame," and "Love Stinks," aided by heavy MTV music video rotation.
- Onstage, Peter Wolf was a cross between a Chicago mobster and Mick Jagger.
- Dana Spiardi wrote, "With a nickname like 'Magic Dick' you'd better be damn good at what you do. And Richard Salwitz is one of the best—harmonica players, that is."[25]

left—J. Geils, Auditorium Theater, Chicago, IL, 1975
right—Peter Wolf, Auditorium Theater, Chicago, IL,1975

NILS LOFGREN

singer, songwriter, electric and acoustic guitars, dobro, pedal steel, lap steel, bottleneck, banjo, keyboards, and accordion

- Lofgren's love for jazz, classical music, and the accordion were primary interests into his early teens.
- Formed the Washington DC-area band Grin in 1968 and opened a few shows for Jimi Hendrix.
- At age 19, he played on Neil Young's *After the Gold Rush* and performed on *Tonight's the Night* a few years later.

- He is a recurring member of the band Crazy Horse.
- Bruce Springsteen asked him to join the E Street Band in 1984.
- Other Lofgren projects include music soundtracks, television award shows, and session work.
- One of his personal thrills came in 1989 as a member of Ringo Starr's All-Starr Band.
- A gymnastics background enabled him to play guitar while doing flips on a trampoline.

left and right—Auditorium Theater, Chicago, IL, 1974

left—Patrick Simmons, International Amphitheater, Chicago, IL, 1977
right—Jeff "Skunk" Baxter, International Amphitheater, Chicago, IL, 1977

DOOBIE BROTHERS

formed 1970; membership through 1979:
Patrick Simmons (guitar, banjo, flute, and vocals),
Tom Johnston (guitar, keyboards, harmonica, and
vocals), John Hartman (drums, percussion, and
backup vocals), Tiran Porter (bass, vocals), Keith
Knudsen (drums, percussion, and vocals), and
Michael McDonald (keyboards, vocals)

- Co-founder Patrick Simmonds has been with the band through all of its active years.
- From inception through the mid-1970s, the Doobie's music was characterized by memorable lead and rhythm guitar hooks, multiple-part harmonies, and an Allman Brothers-style rhythm section.
- From 1976–1982, they coalesced around the keyboards and soulful baritone of Michael McDonald, who led the group through a period of smooth jazz, pop, and white funk.
- Owner of sixteen Top 40 singles (three chart toppers) and several gold, silver, and multi-platinum albums.
- Guitarist Jeff Baxter was a founding member of Steely Dan and played briefly with Jimi Hendrix prior to The Experience.

above—Chicago Stadium, Chicago, IL, 1974

GEORGE HARRISON

guitarist, singer, songwriter, music, and film producer

- Twice inducted into the Rock and Roll Hall of Fame as a member of the Beatles (1988) and as a solo artist (2004).
- The first recipient of the Billboard Century Award honoring music artists with significant bodies of work.
- Organized the 1971 Concert for Bangladesh, the first rock music charity event of its kind.
- "Here Comes the Sun" was written in Eric Clapton's garden using one of Clapton's guitars.
- Frank Sinatra called "Something" the greatest love song of the past half-century.

- "My Sweet Lord" was the best-selling single released by a former Beatle.
- Harrison's best-selling album was the chart-topping, triple disc set, *All Things Must Pass*.
- His Beatles song, "I Me Mine," was the last song the Beatles recorded. John Lennon was AWOL from the session.
- At age 13, he became interested in rock and roll after hearing Elvis Presley's "Heartbreak Hotel."
- Struggled to get his songs accepted and recorded by Lennon and McCartney. He brought Eric Clapton in to play guitar on "While My Guitar Gently Weeps" in order to garner respect for his song.
- Helped popularize the 12-string electric guitar sound, which influenced the Byrds and other bands.

BOB DYLAN

singer, songwriter, guitar, piano, and harmonica

- Inducted into three Halls of Fame: Songwriters (1982), Rock and Roll (1988), and Nashville Songwriters (2002).
- Made his 1961 Greenwich Village debut as an opening act for bluesman John Lee Hooker.
- Warmed up the crowd for Dr. Martin Luther King's famous 1963 "I Have a Dream" speech.
- Dylan's early backing band, The Hawks, went on to become The Band.
- Dylan won a 2008 Pulitzer Prize Jury Award for his profound impact on popular music and American culture.
- He is the winner of eleven Grammy Awards.

right—Chicago Stadium, Chicago, IL, 1974

below—Dylan with the Band's Rick Danko, Robbie Robertson, and Levon Helm, Chicago Stadium, Chicago, IL, 1974

- *Rolling Stone* magazine selected "Like a Rolling Stone" as the greatest rock and roll song of all time and Dylan as the second greatest rock and roll artist of all time.
- Dylan is the first musician to win a Nobel Prize in literature (2016).

PAUL McCARTNEY AND WINGS

formed 1971; two or more years through peak period: Paul McCartney (lead vocals, bass, and other instruments), Linda McCartney (keyboards, vocals), Denny Laine (guitar, vocals), Denny Seiwell (drums, percussion), Henry McCullough (guitar, vocals), Jimmy McCulloch (guitar, vocals), and Joe English (drums, percussion)

- Paul McCartney's first post-Beatles band. Their debut album was widely panned. McCartney's response: "They'll criticize us every time we open our mouths because we're not the Beatles."[26] Wings had the last laugh, selling over 100 million records.
- Their second LP, *Red Rose Speedway*, gave Wings their first number-one album and number-one song, "My Love."
- Guitarist Denny Laine was an original Moody Blues member, and guitarist Henry McCullough played with Joe Cocker's Grease Band at Woodstock.
- Like Yoko Ono, Linda McCartney had her critics. As her singing and playing improved, she harvested defenders like drummer Joe English: "They get sour just because she is not [keyboard virtuoso] Rick Wakeman."[27]

top left—Paul McCartney, Chicago Stadium, Chicago, IL, 1976

bottom left—Denny Laine, Chicago Stadium, Chicago, IL, 1976

- In 1972, the band undertook a clandestine tour of English universities to build band chemistry. McCartney hadn't toured since 1966 with the Beatles.
- Wings' flight ended in 1981, partly due to McCartney's touring concerns following John Lennon's murder.

- In 1973, they topped the charts with their masterwork album, *Band on the Run*. Notions of McCartney's decline were dispelled with songs like "Band on the Run," "Jet," "Helen Wheels," "Let Me Roll It" (a retort to John Lennon), and "Nineteen Hundred and Eighty-Five."

top and bottom—
Paul McCartney,
Chicago Stadium,
Chicago, IL, 1976

CHICAGO

formed 1967; original members through 1978: Walter Parazaider (reed instruments, flute), Terry Kath (guitar, lead vocals), Danny Seraphine (drums), Lee Loughnane (trumpet), James Pankow (trombone), Robert Lamm (keyboards, lead vocals), and Peter Cetera (bass, lead vocals)

- Originally named Chicago Transit Authority for the bus service their first producer rode to school.

- The band's goal was to bring back horns to prominence in a rock and roll band. Not to be ignored were Terry Kath's guitar playing and vocals. Jimi Hendrix was a big Kath fan.

- Chicago has sold a staggering number of records: 21 Top 10 singles, of which ten were No. 1, and 25 platinum-selling albums, of which five successive were chart toppers.

- Long overlooked by the Rock and Roll Hall of Fame, their fortunes changed in 2016.

top—Robert Lamm, Chicago Stadium, Chicago, IL, 1974

bottom— James Pankow, Walter Parazaider, and Lee Loughnane, Chicago Stadium, Chicago, IL, 1974

JOHN McLAUGHLIN

guitarist, bandleader, and composer

- John Coltrane and Miles Davis had a profound influence on McLaughlin's musical development.
- Along with two Grammy Awards, he has won numerous *Guitar Player* and *Down Beat* magazine polls for best jazz and overall guitarist.
- India's culture, philosophy, and music have been part of McLaughlin's life for over 50 years.
- He was one of the first guitarists to play a double-necked electric guitar.
- McLaughlin formed the Mahavishnu Orchestra in 1971. In 1975, he formed Shakti, an acoustic Indo-jazz band that showcased the rhythmic diversity and exotic instruments of Indian classical music.
- Guitarist Pat Metheny said, "McLaughlin has changed the evolution of guitar at least three times, making him one of the most signif-icant figures in the modern history of the guitar."[28]

top right—Auditorium Theater, Chicago, IL, 1974

bottom right—Arie Crown Theater, Chicago, IL, 1975

MARSHALL TUCKER BAND

formed 1971; original lineup: Doug Gray (lead vocals), Toy Caldwell (lead guitar, pedal steel, and vocals), Jerry Eubanks (keyboards, reeds), George McCorkle (rhythm guitar, banjo), Tommy Caldwell (bass, background vocals), and Paul Riddle (drums)

- Practitioners of "crossover country" well before its advent.
- After five decades, singer Doug Gray is the only original member remaining.
- The band was named after a sight-impaired piano tuner.
- Early recognition came as the opening act for the Allman Brothers Band.
- The website Ultimate Classic Rock ranked "Can't You See" as the number-one Southern rock song.
- Bassist Tommy Caldwell was the band's leader and visionary.
- Guitarist Toy Caldwell used his bare thumb (an unorthodox technique) to play lead guitar riffs and construct his distinctive tone.

top left—Toy Caldwell, Northern Illinois University, DeKalb, IL, 1974

bottom left—Tommy Caldwell, Northern Illinois University, DeKalb, IL, 1974

BLACK OAK ARKANSAS

formed 1971; lineup from 1971–1975: Jim "Dandy" Mangrum (lead vocals), Ricky Reynolds (guitar, vocals), Stanley Knight (guitar, organ, and vocals), Harvey Jett (guitar, banjo, and vocals), Pat Daugherty (bass), Wayne Evans (drums), and Tommy Aldridge (replaced Evans)

- Named after Jim Mangrum's tiny hometown. Atlantic Records founder Ahmet Ertegun suggested using it to rile the culturally conservative locals.
- Their brew of hippie country-rock and Dixie swamp-boogie was built around a triple-guitar attack and Mangrum's ribald stage antics and guttural vocals.
- BOA's highest-charting single was a remake of LaVern Baker's 1956 hit, "Jim Dandy." Elvis Presley encouraged Mangrum to record the song because it fit his "dandy" persona.
- Singer Ruby Starr was an honorary member between 1973 and 1976. Her impressive pipes and band chemistry were a welcomed addition on record and stage.

top right—Jim "Dandy" Mangrum, Auditorium Theater, Chicago, IL, 1973

bottom right—Black Oak Arkansas, Auditorium Theater, Chicago, IL, 1973

THE ROLLING STONES

formed 1963; Mick Jagger (lead vocals, harmonica, and guitar), Keith Richards (guitar, vocals), Brian Jones (guitar, other instruments), Bill Wyman (bass, vibraphone), Charlie Watts (drums), Mick Taylor (guitar), and Ronnie Wood (guitar, vocals)

- Quick-thinking Brian Jones came up with the band's name following pressure from a venue owner. Looking down at a Muddy Waters album, he spotted the song, "Rollin' Stone."
- Jagger and Richards are the longest-running songwriting and performing partnership ever.
- No music act has performed for more people worldwide or grossed more revenues than the Stones.

- Pianist Ian Stewart was the "sixth Stone" on stage and in the studio until his death in 1985. His future in the band was derailed by early manager Andrew Loog Oldham, who said he didn't look the part and was one Stone too many.
- Mick Jagger bristled at the moniker, "greatest rock and roll band in the world," broadcast prior to shows by tour manager Sam Cutler.
- Jagger, Richards, and Watts fired the band's pivotal creator, Brian Jones, in June of 1969. He was found dead floating in his pool less than a month later—the result of drugs, alcohol, and various health conditions.
- On July 5, 1969, the band introduced new guitarist Mick Taylor. Many reasons have been given for Taylor's unexpected departure in 1974. Keith Richards recalled, "We did the

previous page—Ron Wood, Mick Jagger and Keith Richards, Chicago Stadium, Chicago, IL, 1975
left—Mick Jagger, Chicago Stadium, Chicago, IL, 1975
right—Keith Richards, Chicago Stadium, Chicago, IL, 1975

most brilliant stuff together, and some of the most brilliant stuff the Stones ever did. I was in awe sometimes, listening to Mick Taylor, especially on that slide."[29]

- In 1972, President Richard Nixon's State Department declared the Stones "The most dangerous rock and roll band in the world."[30]
- Ronnie Wood, former Jeff Beck Group bassist and guitarist for The Faces and Rod Stewart, replaced Taylor in June of 1975. He dreamed of becoming a Rolling Stone after seeing them perform in 1963.

- In 1993, Bill Wyman left the Stones. He no longer wanted to fly and had too many other interests.
- The Rolling Stones were 1989 Rock and Roll Hall of Fame inductees.
- The words, "I can't get no satisfaction" are part of a lyric from a Chuck Berry song titled "30 Days."
- The Stones' version of Willie Dixon's "Little Red Rooster" was the first genuine blues record to reach No. 1 in England. It was banned from U.S. play due to the lyrics.

left—Mick Jagger, Chicago Stadium, Chicago, IL 1975
right—Keith Richards, Chicago Stadium, Chicago, IL 1975

TODAY
'60s and '70s Rockers Who Are/Were Still Rockin' in Their 60s and 70s

previous page—Ann Wilson of
Heart, The Arcada Theater,
St. Charles, IL, 2018
this page—Robert Plant of
Led Zeppelin, The Vic,
Chicago, IL, 2016

Paul Rodgers of
Bad Company and Free,
RibFest, Naperville, IL, 2015

below, left—Randy Bachman of The Guess Who and BTO, The Arcada Theater, St. Charles, IL, 2016
below, right—Glenn Hughes of Deep Purple, Reggies, Chicago, IL, 2016

previous page, top left—Steve Cropper of Booker T. & The M.G.'s and The Blues Brothers, The Arcada Theater, St. Charles, IL, 2018

previous page, top right—Joan Jett of The Runaways, Allstate Arena, Rosemont, IL, 2015

previous page, bottom—Howard Leese of Heart, RibFest, Naperville, IL, 2015

above—Gene Simmons of Kiss, The Arcada Theater, St. Charles, IL, 2018

right—Ted Nugent of Amboy Dukes, The Arcada Theater, St. Charles, IL, 2016

Paul Quinn of Saxon,
The Arcada Theater, St. Charles, IL, 2017

Mick Box of Uriah Heep,
The Arcada Theater,
St. Charles, IL, 2018

Andy Powell of Wishbone Ash,
The Arcada Theater,
St. Charles, IL, 2016

previous page, top—Dusty Hill and Billy Gibbons of ZZ Top, Ribfest, Naperville, IL, 2012

previous page, bottom left—Eric Bloom of Blue Oyster Cult, The Arcada Theater, St. Charles, IL, 2016

previous page, bottom right—Buck Dharma of Blue Oyster Cult, The Arcada Theater, St. Charles, IL, 2016

right—Ronnie Montrose of Montrose, The Edgar Winter Group, and Gamma, Penny Road Pub, Barrington, IL, 2011

below—Geezer Butler, Ozzy Osbourne, and Tony Iommi, Black Sabbath, United Center, Chicago, IL, 2016

Andy Parker of UFO,
House of Blues,
Chicago, IL, 2011

Phil Mogg of UFO,
The Arcada Theater,
St. Charles, IL, 2017

Paul Raymond of UFO and Savoy Brown,
House of Blues, Chicago, IL, 2011

Mark Farner of Grand Funk Railroad,
The Arcada Theater, St. Charles, IL, 2017

Mik Kaminski of Electric Light Orchestra,
The Arcada Theater, St. Charles, IL, 2017

Jon-Luc Ponty of The Mahavishnu Orchestra
and Frank Zappa, The Arcada Theater,
St. Charles, IL, 2016

previous page, top left—Lou Gramm of Foreigner, The Arcada Theater, St. Charles, IL, 2016

previous page, top right—Roger Hodgson of Supertramp, The Arcada Theater, St. Charles, IL, 2016

previous page, bottom—Jon Anderson of Yes, The Arcada Theater, St. Charles, IL, 2016

above—Carl Palmer of Emerson, Lake and Palmer, The Arcada Theater, St. Charles, IL, 2017

right—Joe Ely, The Space, Evanston, IL, 2012

Martin Barre of Jethro Tull,
Reggies, Chicago, IL, 2016

above—Ian Anderson of Jethro Tull, The Vic, Chicago, IL, 2009
below—Steve Priest of The Sweet, The Arcada Theater, St. Charles, IL, 2018

left—Mike Love of The Beach Boys, River Edge Park, Aurora, IL, 2016

below—Brian Wilson of The Beach Boys, Jeff Beck, and Al Jardine of The Beach Boys, Riverside Theater, Milwaukee, WI, 2013

following page, top—Leon Russell, Mayne Stage, Chicago, IL, 2012

following page, bottom left—Ian Hunter of Mott The Hoople, Old Town School of Folk Music, Chicago, IL, 2011

following page, bottom right—Mark Andes of Spirit, Jo Jo Gunne, and Firefall, The Arcada Theater, St. Charles, IL, 2017

above—Roger Daltrey and Pete Townshend of The Who, Allstate Arena, Rosemont, IL, 2015
following page, top—Peter Noone of Herman's Hermits, The Arcada Theater, St. Charles, IL, 2016
following page, bottom left—Ian McLagan of Faces, Fitzgerald's, Berwyn, IL, 2015
following page, bottom right—Petula Clark, The Arcada Theater, St. Charles, IL, 2017

this image—Rod Argent of The Zombies and Argent, Mayne Stage, Chicago, IL, 2013

below, left—Dave Davies of The Kinks, The Arcada Theater, St. Charles, IL, 2017

below, right—Kim Simmonds of Savoy Brown, Fitzgerald's, Berwyn, IL, 2011

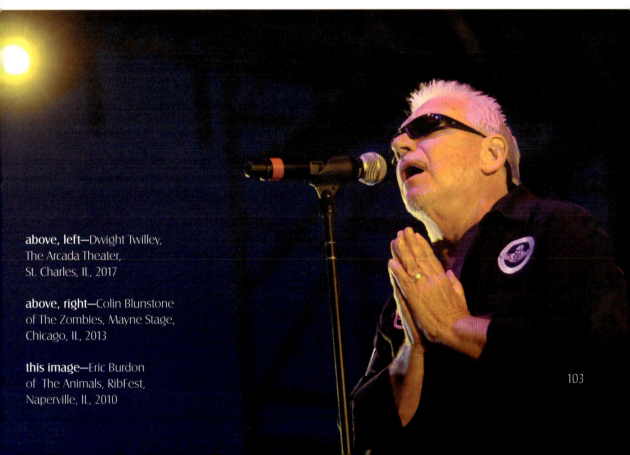

above, left—Dwight Twilley,
The Arcada Theater,
St. Charles, IL, 2017

above, right—Colin Blunstone
of The Zombies, Mayne Stage,
Chicago, IL, 2013

this image—Eric Burdon
of The Animals, RibFest,
Naperville, IL, 2010

Chuck Negron of Three Dog Night,
The Arcada Theater,
St. Charles, IL, 2018

John Sebastian of The Lovin' Spoonful,
Prairie Center for the Arts,
Schaumburg, IL, 2017

top left—Burton Cummings of The Guess Who, The Arcada Theater, St. Charles, IL, 2017
top right—John Kay of Steppenwolf, RibFest, Naperville, IL, 2010
below—Felix Cavaliere of The Rascals, The Arcada Theater, St. Charles, IL, 2018

above, left—Mitch Ryder of The Detroit Wheels, The Arcada Theater, St. Charles, IL, 2017

above, right—Tommy James of The Shondells, The Arcada Theater, St. Charles, IL, 2018

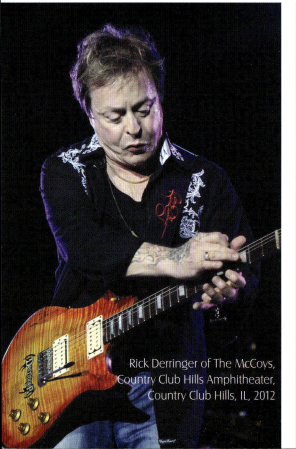

Rick Derringer of The McCoys,
Country Club Hills Amphitheater,
Country Club Hills, IL, 2012

South Side Johnny of The Asbury Jukes,
The Arcada Theater, St. Charles, IL, 2016

Jose Feliciano,
The Arcada Theater,
St. Charles, IL, 2016

Pete Rivera of Rare Earth,
Genesee Theater,
Waukegan, IL, 2014

above—Dennis DeYoung of Styx, Arlington Park Fest, Arlington Heights, IL, 2015

below—Larry Millas, Jim Peterik, and Bob Bergland of The Ides of March, The Arcada Theater, St. Charles, IL, 2017

Tom Doody and J.C. Hooke of
The Cryan' Shames,
The Arcada Theater, St. Charles, IL, 2016

Danny Seraphine of Chicago,
The Arcada Theater,
St. Charles, IL, 2016

top, left—Carl Giammarese of The Buckinghams,
The Arcada Theater, St. Charles, IL, 2016

below, left—Dennis Tufano of The Buckinghams,
The Arcada Theater, St. Charles, IL, 2017

below, right—Ronnie Rice of The New Colony Six,
The Arcada Theater, St. Charles, IL, 2016

Carmine Appice of Vanilla Fudge and Cactus,
Genesee Theater, Waukegan, IL, 2014

Jimy Sohns of The Shadows of Knight,
The Arcada Theater, St. Charles, IL, 2016

Steve Miller, RibFest,
Naperville, IL, 2012

above, left—Boz Scaggs, The Arcada Theater, St. Charles, IL, 2017
above, right—Doug Gray of The Marshall Tucker Band, The Arcada Theater, St. Charles, IL, 2017

Stephen Stills of Crosby, Stills, Nash and Young
and Buffalo Springfield,
The Arcada Theater, St. Charles, IL, 2017

Dewey Bunnell and Gerry Beckley
of America, The Arcada Theater,
St. Charles, IL, 2016

Dave Mason of Traffic,
The Arcada Theater,
St. Charles, IL, 2018

Don Felder of The Eagles,
The Arcada Theater,
St. Charles, IL, 2016

left—Artimus Pyle of Lynyrd Skynyrd,
The Arcada Theater, St. Charles, IL, 2017

below—Jorma Kaukonen of Jefferson Airplane
and Hot Tuna, The Space, Evanston, IL, 2018

following page, top—Don Barnes of
38 Special, The Arcada Theater,
St. Charles, IL, 2016

following page, bottom left—Jim "Dandy"
Mangrum of Black Oak Arkansas,
The Arcada Theater, St. Charles, IL, 2016

following page, bottom right—
Mickey Thomas of Jefferson Starship,
The Arcada Theater, St. Charles, IL, 2018

above, left—David Bromberg, Prairie Center for the Arts, Schaumburg, IL, 2017
above, right—Al Stewart, The Arcada Theater, St. Charles, IL, 2017

Emmylou Harris,
The Vic,
Chicago, IL, 2016

below, left—Arlo Guthrie, Elgin Community College, Elgin, IL, 2017
below, right—Elliot Lurie of Looking Glass, The Arcada Theater, St. Charles, IL, 2017

Buddy Guy,
Genesee Theater,
Waukegan, IL, 2009

left—Edgar Winter of The Edgar Winter Group, Country Club Hills Amphitheater, Country Club Hills, IL, 2012
below, left—Johnny Winter, Clearwater Theatre, Dundee, IL, 2008
below, right—Cesar Rosas of Los Lobos, Fitzgerald's, Berwyn, IL, 2015

Robert Cray, Blues Fest,
Naperville, IL, 2011

Roger Earl of Savoy Brown and Foghat,
The Arcada Theater, St. Charles, IL, 2017

Rolling Stones, United Center,
Chicago, IL, 2013

ENDNOTES

1. *Rolling Stone* magazine. Quote by Dave Grohl. "The Immortals," April 2005.
2. *New York Times*. Larry Rohter, "A Guitar Hero Won't Play the Game." Feb. 2, 2010.
3. Marco della Cava, "Rock Legend Jeff Beck Looks Ahead and Back." *USA Today*. Feb. 22, 2011.
4. Mark McDermott, "Not All Great Bands Have Greatest Hits." *Easy Reader News*. www.easy-readernews.com. March 4, 2011.
5. Tom Guerra, "Tom Guerra Interviews Rick Derringer." *Vintage Guitar* magazine. November 2001.
6. Lowell Cauffiel, "Tommy Bolin Interview." *Guitar Player* magazine. March 1977.
7. Campbell Devine, *All the Young Dudes: Mott the Hoople & Ian Hunter—The Biography*. From the Forward by Brian May. Cherry Red Books, 1998.
8. Unattributed author. "Trailblazers: Paranoid." *Total Guitar* magazine. Aug. 2005.
9. Josh Tyrangiel, "100 Albums of All Time." *Time* magazine. Jan. 26, 2010.
10. B.B. King, "Blues Brothers." *Reader's Digest*. 2001.
11. Staff writer. *Guitar World* magazine. Nov. 19, 2013.
12. *Brainy Quotes*. www.brainyquotes.com/authors/b_b_king, 2001–2008.
13. *Rock and Roll Hall of Fame* website, www.rockhall.com.
14. Marshall Ward, "The Heart of Ann Wilson." *Rock Cellar* magazine. April 2013.
15. Charles Shaar Murray, "The Rise and Decline of The Kinks." *New Musical Express*. Oct.6, 1979.
16. Peter Gerstenzang, "Q & A With New York Dolls Guitarist Sylvain Sylvain." *New York Village Voice*. March 15, 2011.
17. Joe Matera, "Every Home Should Have One: New York Dolls' Debut Album." *Classic Rock*. http://classic.teamrock.com/features/2014-04-24. April 24, 2014.
18. Douglas Noble, "Trower's Travels." *Guitar* magazine. April 2, 1993.
19. Joel Reese, "The Brief, Sordid Reign of '70s Rock Legends UFO." *Concourse-Deadspin* website. www.theconcourse.deadspin.com. Dec. 12, 2014.
20. Mike Ragogna, "Still a Wizard, a True Star." *Huffington Post* website. www.huffingtonpost.com/mike-ragnogna. May 6, 2012.
21. Jerry Korb, "The Mellotron." *Mike Pinder* website. www.mikepinder.com.
22. Simmy Richman, "The Stephen Stills Interview." *The Independent* website. www.independent.co.uk/arts-entertainment. Aug. 17, 1974.
23. Cameron Crowe, "Stephen Stills Interview." *Creem* magazine. September 1974.
24. *Peter Frampton* website. www.frampton.com. 2010.
25. Dana Spiardi, "Magic Dick Salwitz: Still Whammin' and Jammin' at 72." *The Hip Quotient* website. www.hipquotiant.com/the-magic-dic.
26. Paul Gambaccini, "McCartney's Meet Press: Starting All Over Again." *Rolling Stone* magazine. June 21, 1973. From the website *Rock's Back Pages*. www.rocksbackpages.com.
27. Uncredited writer. "Wings Take Off With New Member." *Beat Instrumental*. July 1975.
28. "Q&A: Other Musicians." *Pat Metheny* website. www.patmetheny.com/qa. March 24, 1999.
29. *Life By Keith Richards*, page 271. Back Bay Books/Little, Brown and Company, 2010.
30. *Ibid.*, page 3.

INDEX

AMHERSTMEDIA.COM